His Marvelous Creatures

Created By

Jan Asleson

Dedicated to the greatest
Creator of All! Jesus!
To Brenda Risner and Sheryl
Chism Runyon for all your help
and support in completing this
work, and to all those who love
and care for His Marvelous
Creatures.

"Now the Lord God had formed out of the ground all the wild animals and all the birds in the sky. He brought them to the man to see what He would call them; and whatever man called each living creature, that was its name."

Genesis 2:19

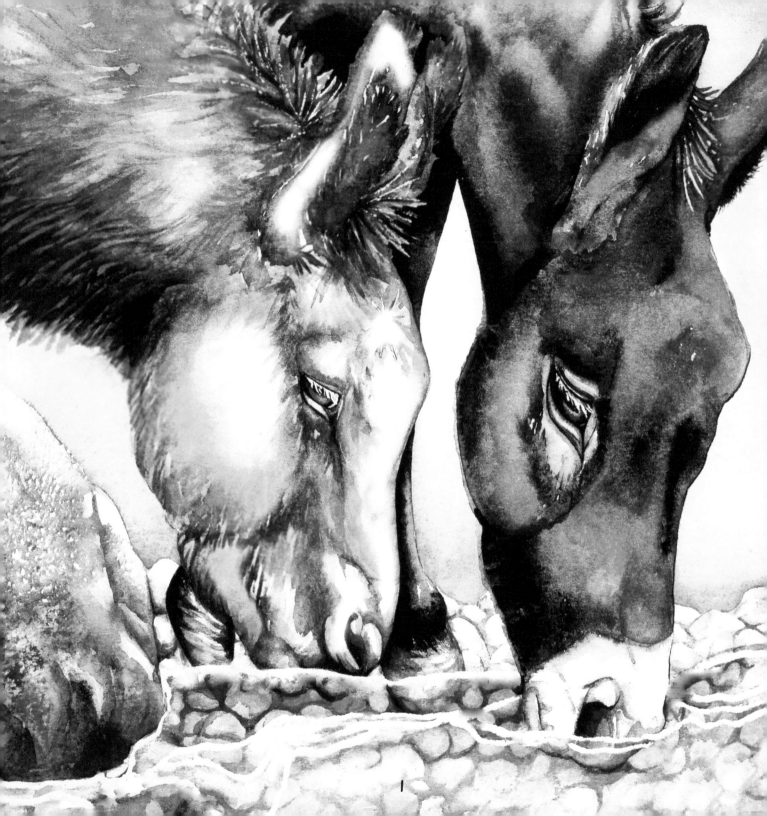

He sends springs in the valleys;

they flow between the mountains;

they give drink to every animal

of the fields; the wild donkeys

quench their thirst

Beside them the birds

of heaven dwell; they

lift up their voices

among the branches

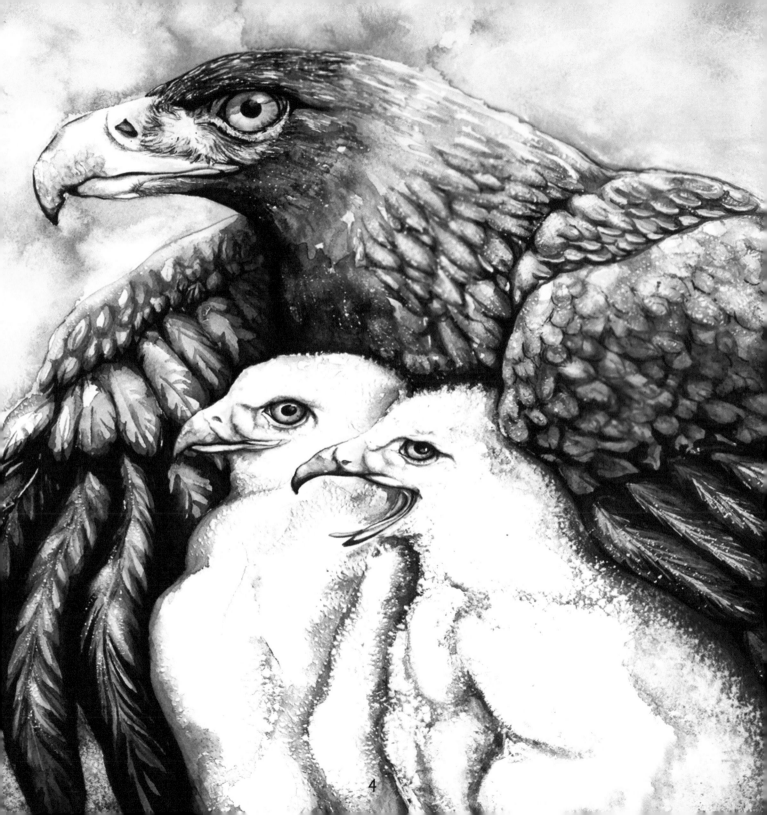

4

The high hills are a refuge

for the wild goats and the

rocks for the badgers

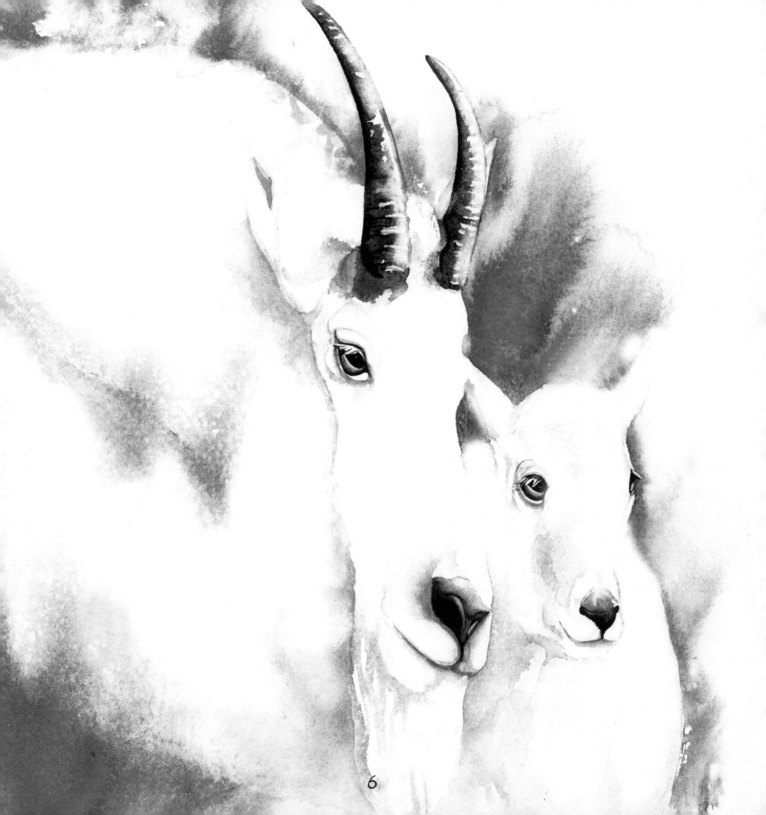

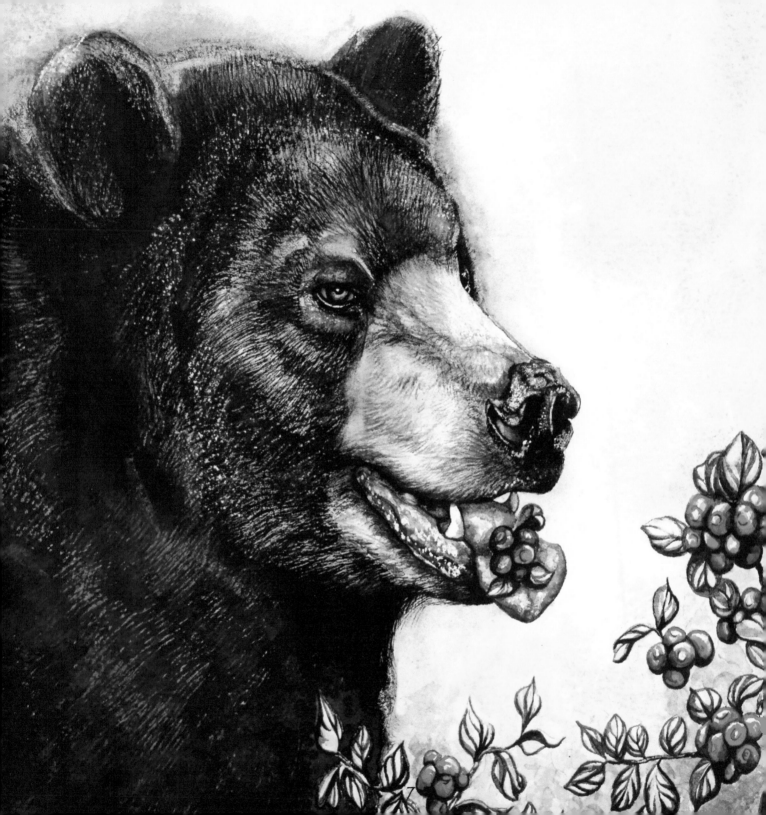

He gives the animals

their food....

And to the young ravens

that cry

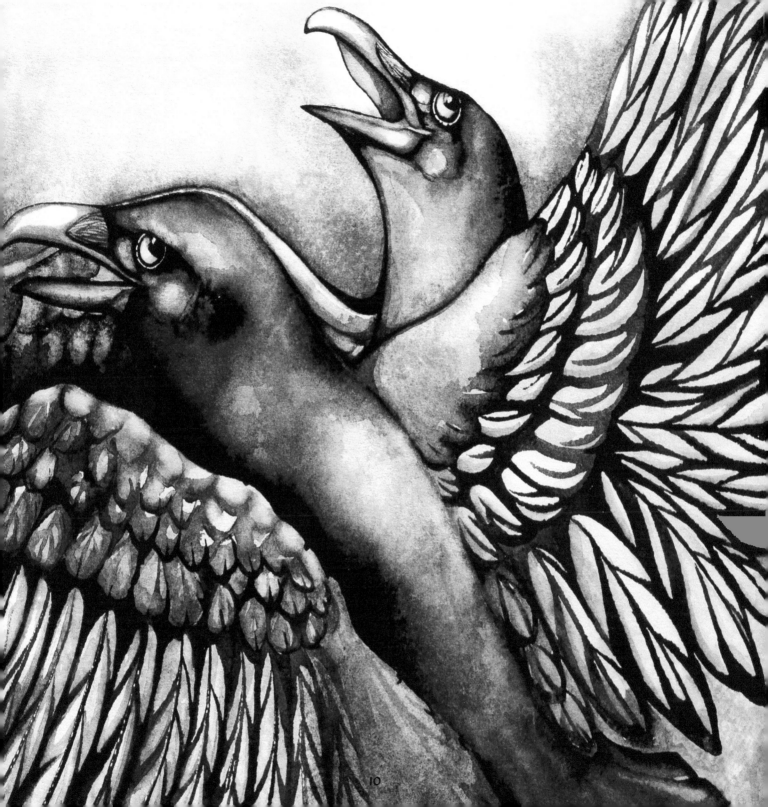

The animals of the field

will glorify me; the wild

dogs and the owls

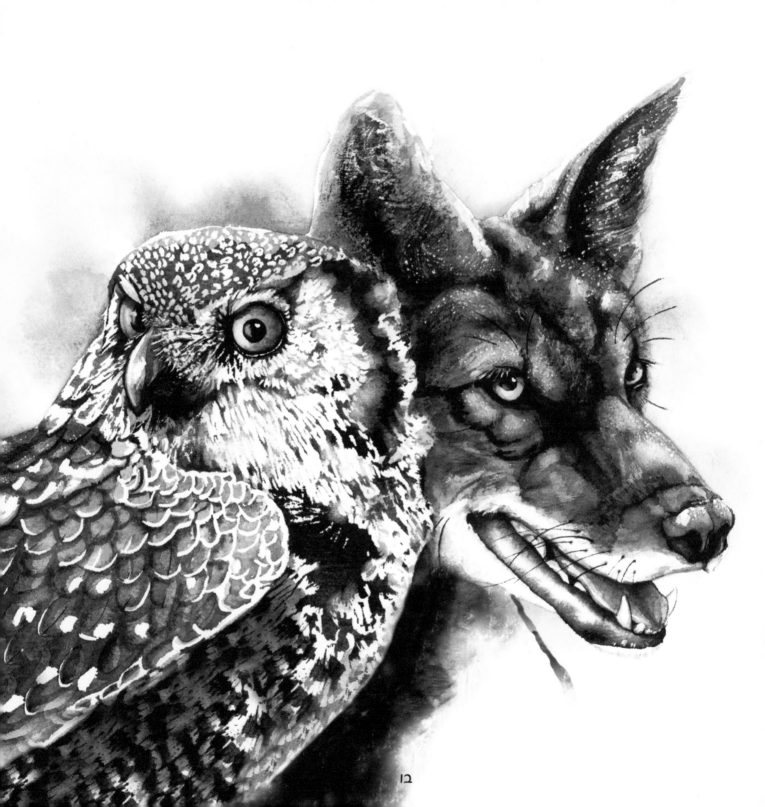

For every creature

of the forest is Mine...

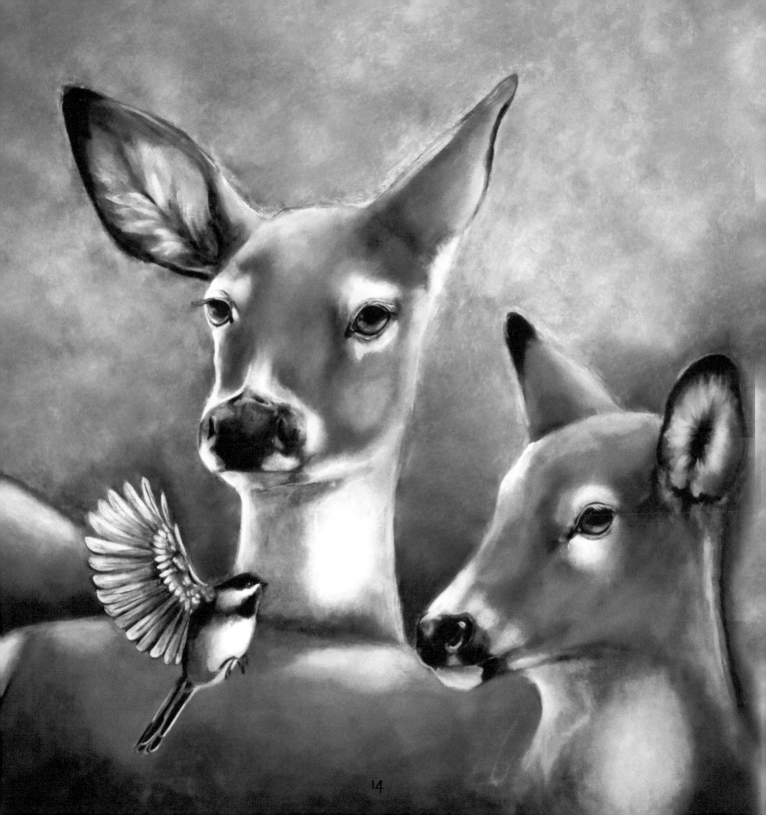

The cattle on

a thousand hills

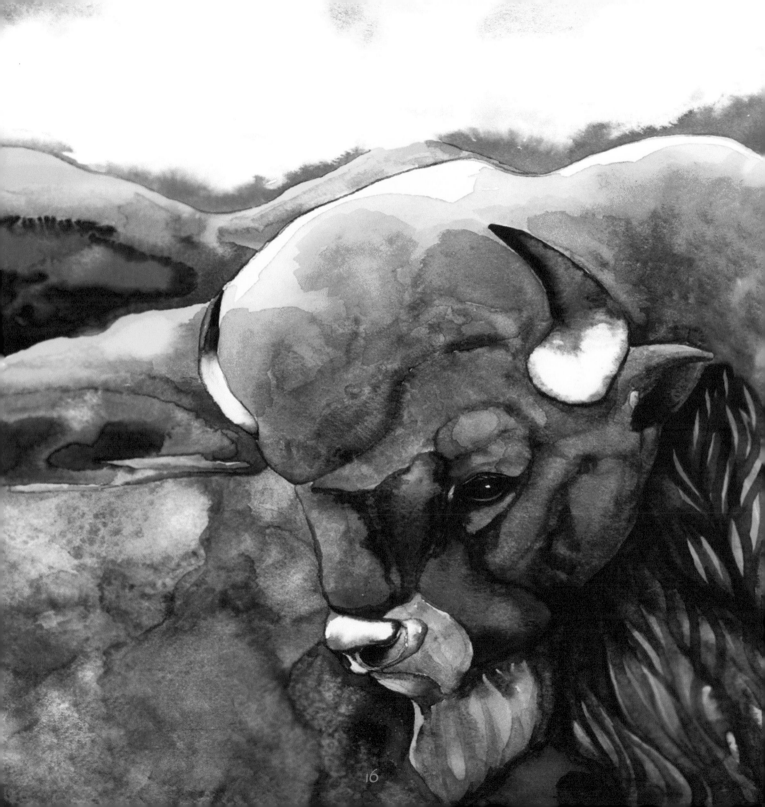

I know of every bird

of the mountains,

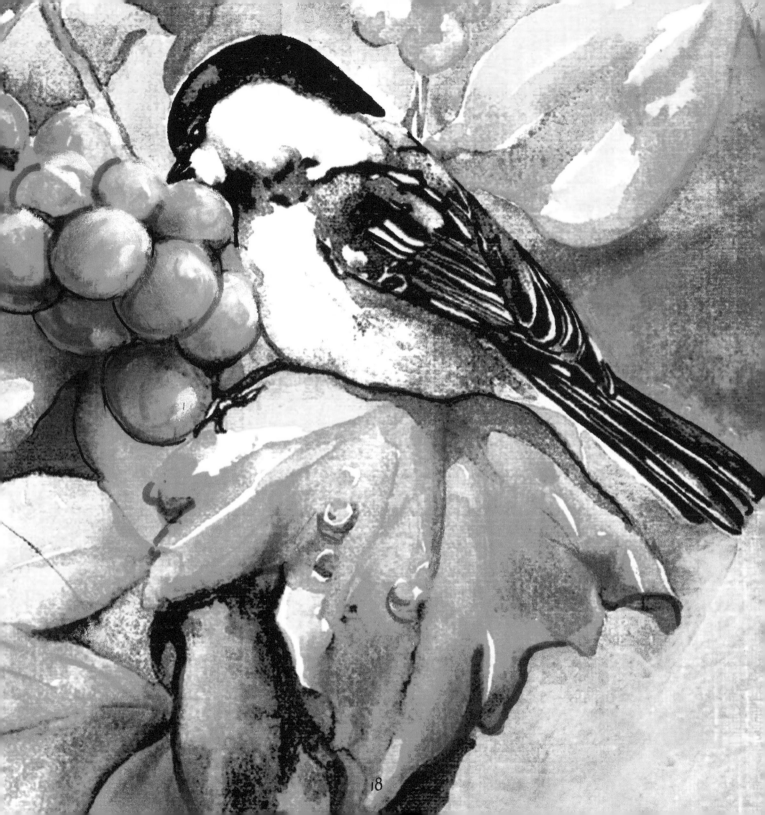

And everything that

moves in the field

is Mine

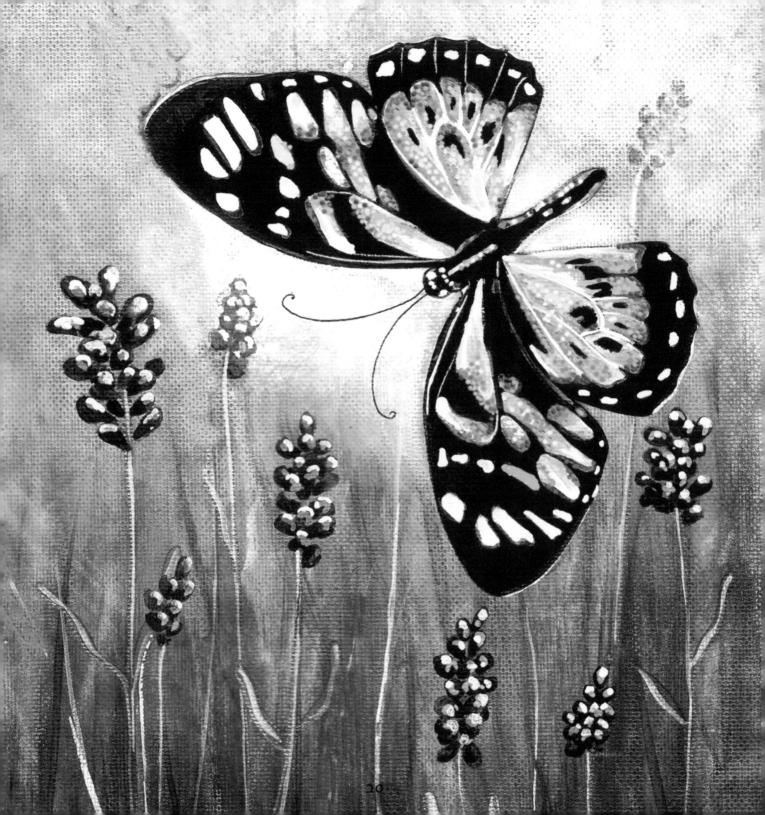

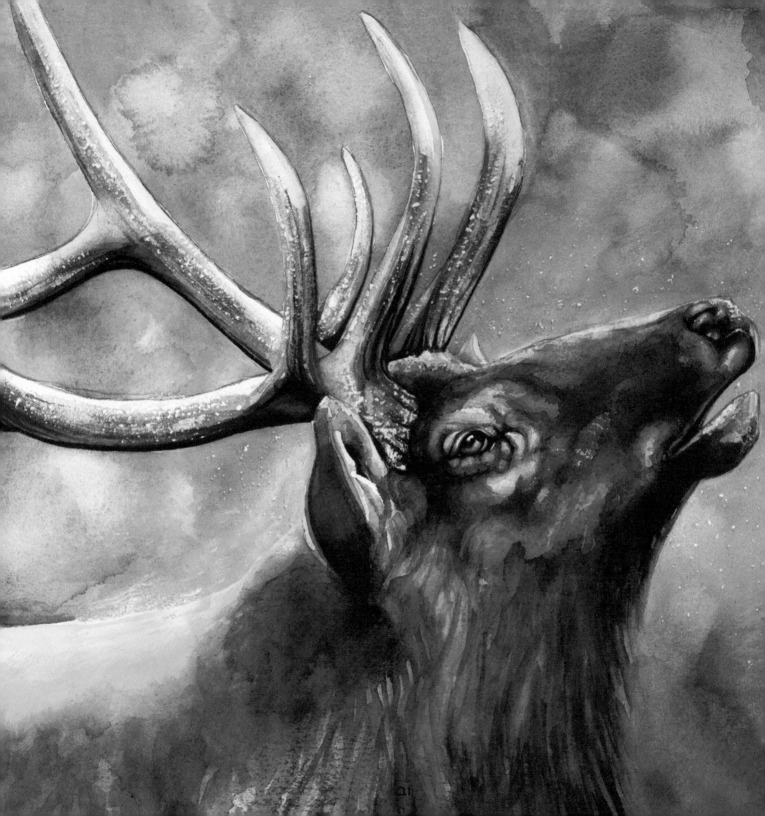

But ask the animals

and they will teach

you...

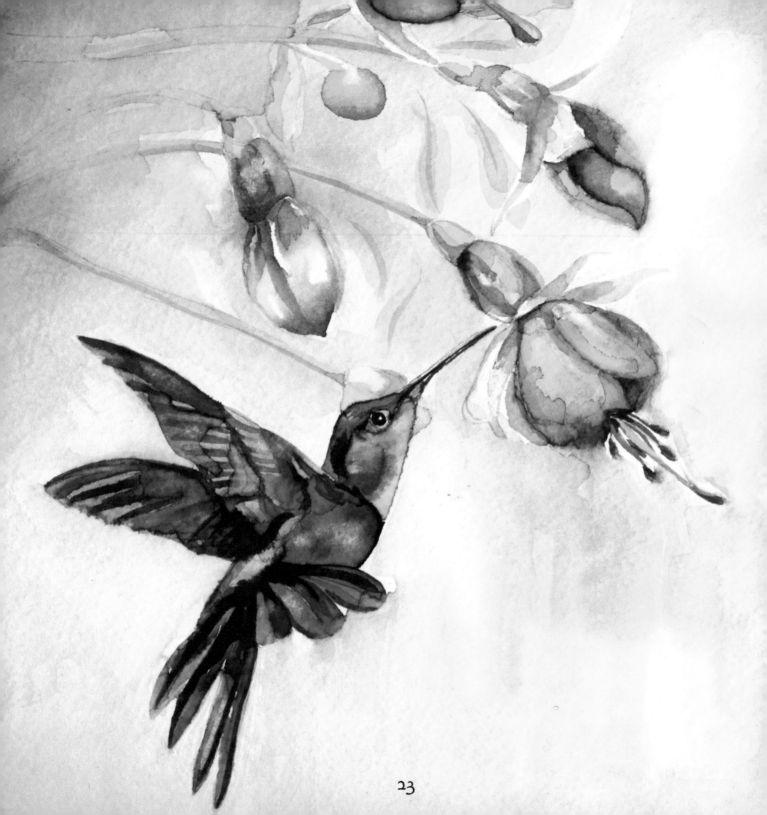

Or the birds in the

sky, and they will tell you

Or speak to the earth,

and let it teach you; and

let the fish of the sea

tell you

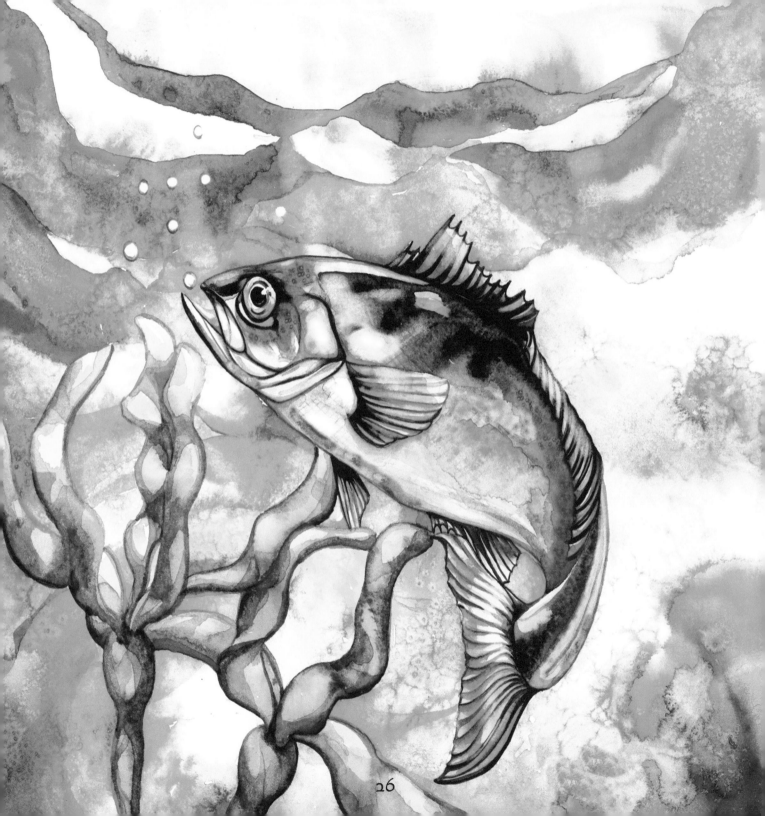

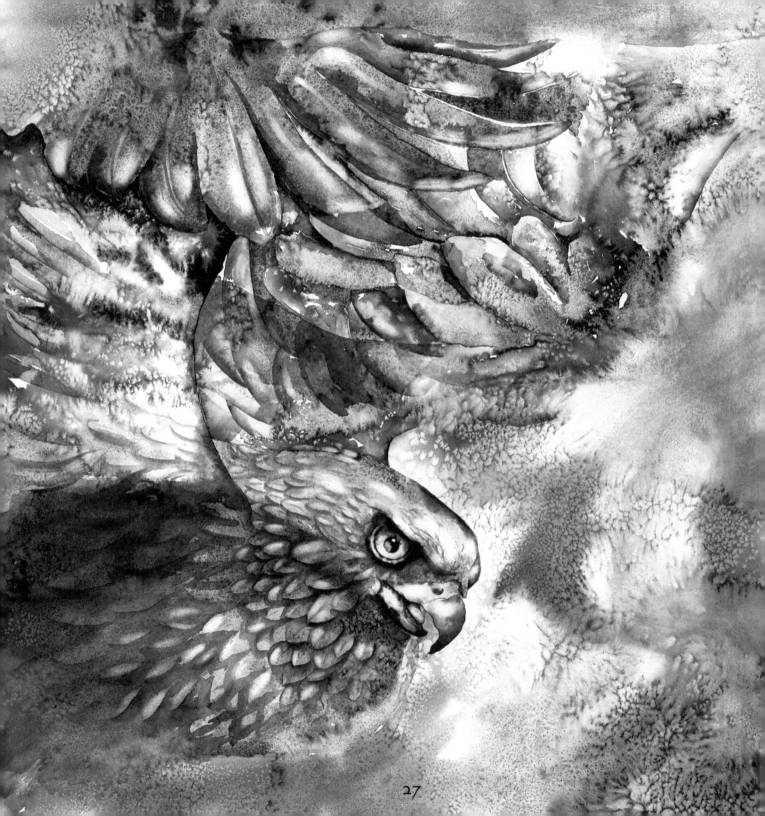

Who among all these

does not know that the

Hand of the Lord has

done this,

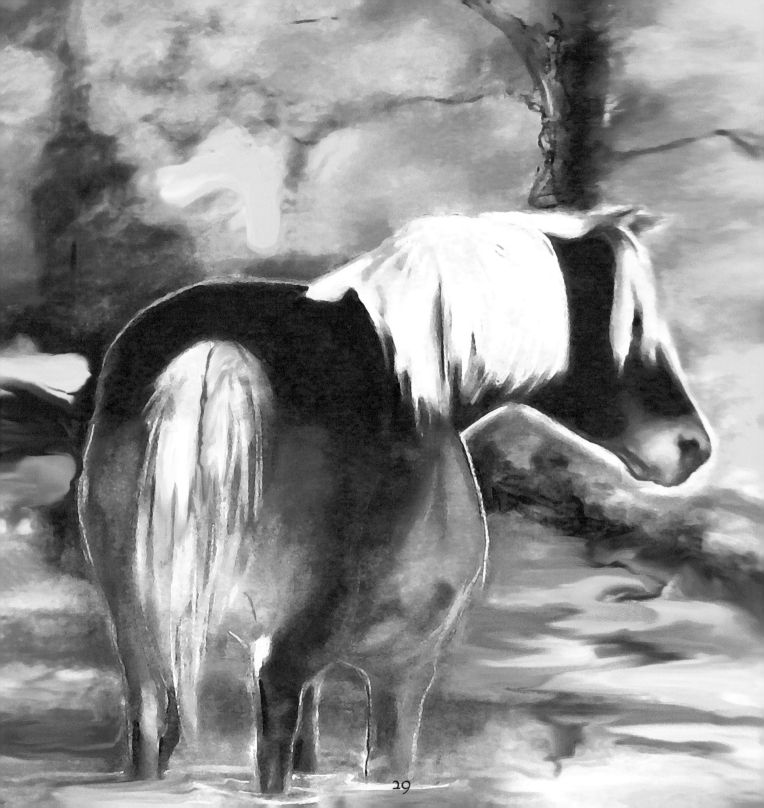

In whose Hand us the life

of every living thing, and

the breathe of all mankind?

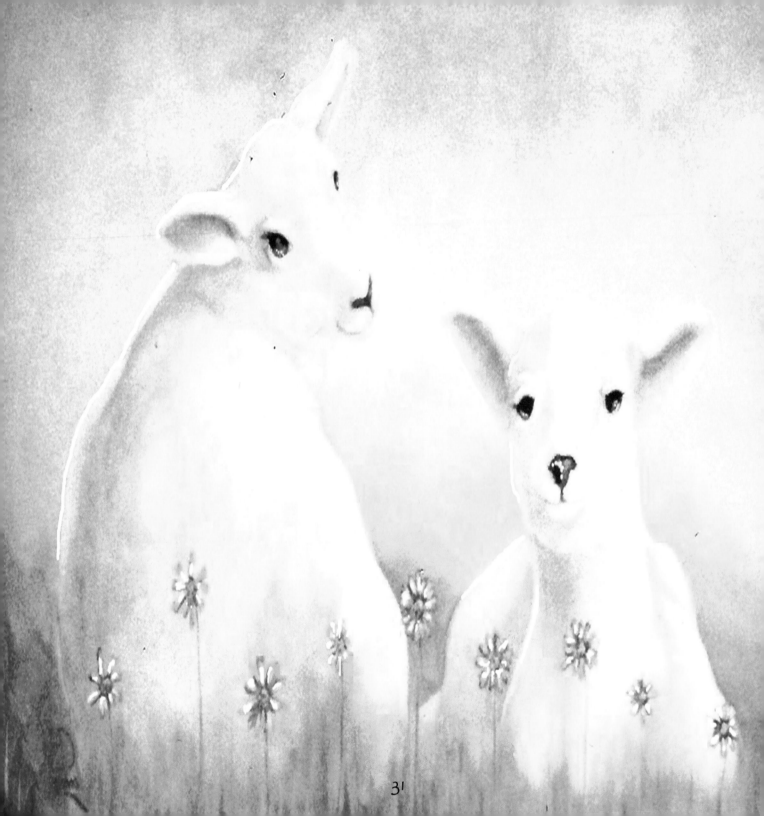

Your righteousness is like the

mountains; Your judgments

are like a great deep O Lord,

You preserve both man and

beast.

I am a lover of animals, primarily because I see the handiwork of God the Creator in them. So much of His character is revealed in nature. Power, beauty, majesty, strength, gentleness, are just a few of His marvelous attributes. And He says that these creatures can teach us and tell us of Him and His greatness. In His love for us, He gave us the colorful birds and butterflies, the animals of the forest and the fields, mountains and seas, for us to marvel at and to enjoy. The breath of life dwells within the creatures of God. He declared their creation to be very good. He personally cares for them and is even involved in feeding them. In the same way He cares for them, He calls us to be good stewards of His creation. We are responsible to Him for the way we treat it. We should respect the creatures as God's creation. They are worthy of our care! As you consider His handiwork, know that He loves you so much more than these!

Your Creature Memories

Do you have a special memory of a pet or animal that you took care of, or that touched your life? Write it down here.

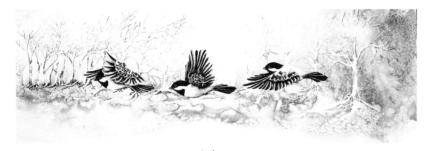

 Jan Asleson - Author/Illustrator

My designs are inspired by a desire to share
with others the beauty of God's creation that
I see around me. My passion is to encourage others
through my artistic mediums to not give up on their
dreams, to recognize the Blessings all around them
and to know that there is always hope.

I find my creativity in many mediums including
watercolor, acrylics, pastels, oils, jewelry design,
book illustration work, silk art, metal work,
watercolor and portraiture.

I live in South-East Kansas with my husband David.

You can find me at www.spiritwingsdesigns.com

"But ask the animals, and they will teach you, or the birds of the sky, and they will tell you; or speak to the earth, and it will teach you, or let the fish in the sea inform you. Which of all these does not know that the hand of the Lord has done this? In His hand is the life of every creature." Job 12:7-10

"God made the wild animals according to their kinds, the livestock according to their kinds, and all the creatures that move along the ground according to their kinds. And God saw that it was good." Genesis 1:25

"God blessed them and said to them, "Be fruitful and increase in number; fill the earth and subdue it. Rule over the fish in the sea and the birds in the sky and over every living creature that moves on the ground." Genesis 1:28-29

"Your righteousness is like the highest mountains, your justice like the great deep. You, Lord preserve both man and beast." Psalm 36:6

"For every animal of the forest is mine, and the cattle on a thousand hills." Psalm 50:10-11

"He provides food for the young ravens when they call."

Psalm 147:9

"The righteous care for the needs of their animals."

Proverbs 12:10

"The eyes of all look to you, and you give them their food at the proper time. You open your hand and satisfy the desires of every living thing." Psalm 145:15-16

"How many are your works, Lord! In wisdom you made them all; the earth is full of your creatures."

Psalm: 104:10,11,12,18,27

"You made man rulers over the works of your hands; you put everything under their feet: all flocks and herds, and the animals of the wild, the birds in the sky, and the fish in the sea, all that swim the paths of the sea." Psalm 8:6-8

CPSIA information can be obtained
at www.ICGtesting.com
Printed in the USA
BVHW021531210219
540841BV00002B/2/P